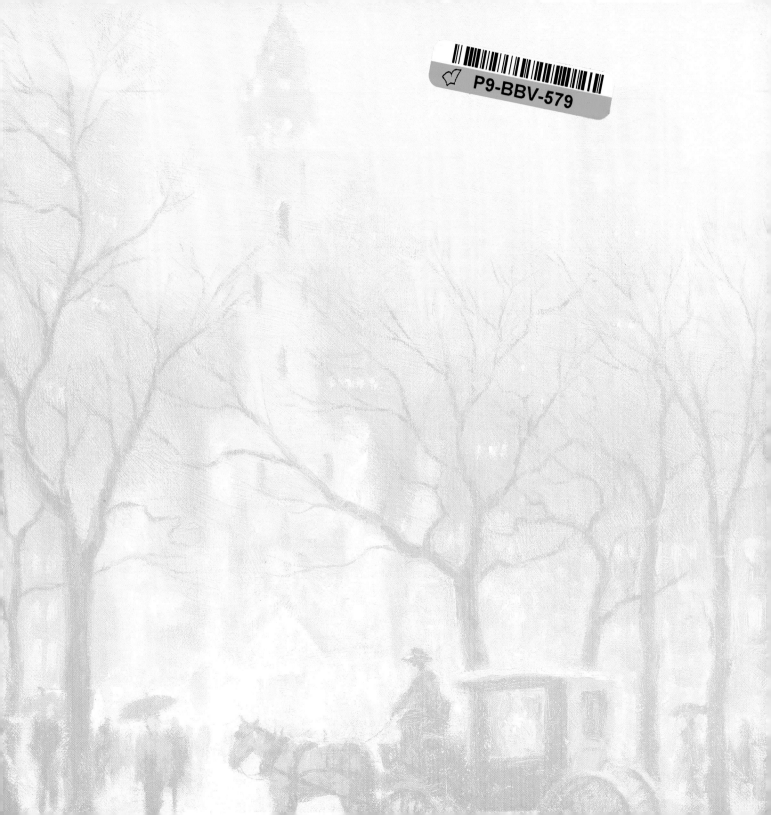

THOMAS KINKADE

Sea to Shining Sea

Harvest House Publishers

Eugene, Oregon

Thomas Kinkade's
Sea to Shining Sea

Text Copyright © 2001 by Media Arts Group, Inc., Morgan Hill, CA 95037
and Harvest House Publishers, Eugene OR 97402
Published by Harvest House Publishers
Eugene, Oregon 97402

Library of Congress Cataloging-in-Publication Data
Kinkade, Thomas, 1958-
 Thomas Kinkade's sea to shining sea/ Thomas Kinkade.
 p. cm. - (Chasing the horizon collection)
 ISBN 0-7369-0779-3
 1. Kinkade, Thomas, 1958—Themes, motives. 2. Plein air painting–United States.3.
United States–In art. I. Title; Sea to shining sea. II. Title. III. Series.

 ND237.K535 A4 2001
 759.13–dc21
 2001024436

Media Arts Group, Inc.
900 Lightpost Way
Morgan Hill, CA 95037
1-800-366-3733

Design and production by Koechel Peterson & Associates, Minneapolis, Minnesota

Scripture quotations are taken from: *The Living Bible*, Copyright © 1971. Used by permission of Tyndale House Publishers, Inc., Wheaton, Illinois 60189. All rights reserved; and The Holy Bible: New International Version®. NIV®. Copyright© 1973, 1978, 1984 by the International Bible Society. Used by permission of Zondervan Publishing House.

Printed in the United States of America

01 02 03 04 05 06 07 08 09 10 /IP/ 10 9 8 7 6 5 4 3 2 1

Sea to Shining Sea

A note from

Thomas Kinkade

When people first see my studio paintings of warm, lighted homes surrounded by lovely gardens their first remark is usually something like, "Gee, I wish I could step into that painting and visit for a while." This is often followed by one of two questions: "Is this a real place?" Or "Where do you get the ideas for your paintings?"

The answer to the first question is that the homes that serve as models for most of my studio paintings are very real places, though I do admit to a bit of remodeling as I transfer the existing home to the canvas. As for the second question, the inspiration for all I do comes from the things about which I'm most passionate.

All good artists are influenced by their passions. This is true of all the arts—poetry, drama, literature, music, or painting. And to the extent that artists are able to convey those passions in their work, they will be successful.

For me, the main passion of my art has been my fascination with light. In all my work, light is, in some way, essential to the theme. For this reason, I've earned the reputation as the Painter of Light®. But like most artists, there are other passions that also influence my work.

Two of those passions that bear on this present volume are my reverence for nature and my love of travel. For as long as I can remember, I've enjoyed venturing off to new and promising destinations. It's a trait I no doubt inherited from my father who, when I was a boy, would take off on some fanciful journey, just to see where

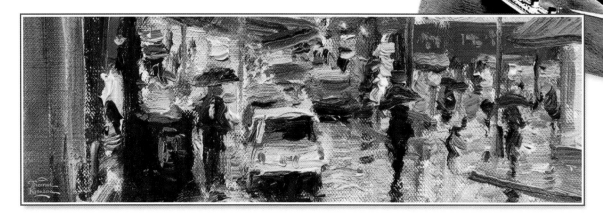

this or that road would take him.

This innate Kinkade curiosity holds great rewards for a man like myself who likes to apply paint to canvas. Often during my travels, I'll notice the sunlight falling with a certain delightful slant on a setting that begs to be captured in oils. Early in my career I would miss out on such opportunities because I was unprepared to paint. So, after several frustrating episodes, I assembled a small rolling portable easel that now accompanies me on my forays into parts unknown. By now, those who travel with me are accustomed to my pulling to the side of the road and setting up shop while they wander off to sightsee or settle in with a good book.

As for my love of nature, it was this passion that prompted me a number of years ago to experiment with the Impressionistic "plein air" technique of painting. *Plein air* literally means "open air" in French and is usually associated with names such as Claude Monet, Auguste Renoir, and Eduoard Manet. This art form has been particularly successful for me because, as with my traditional studio work, light plays an important part. A plein air painting is done much more quickly than studio paintings—the available light is often fleeting and must be taken advantage of on the spot. Also a plein air artist is more interested in capturing the essence of a place, rather than minute detail.

Plein air painting gives me the excuse to sit, often for hours at a time, and observe the beauty of creation. Now, even when I'm not painting, I've formed the habit of quietly absorbing the natural world around me, gazing with awestruck wonder at the

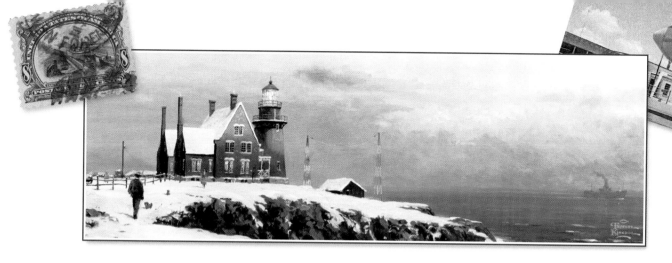

surrounding beauty. Learning this habit has been one of the keys to a joy that, like nature, renews itself season by season. In plein air, my love of light, nature, and travel all converge in the creation of art that many of my fans enjoy as much as the more traditional work for which I'm known. As a bonus, I've found that the communion with nature afforded by this impressionistic technique has greatly enhanced my studio paintings.

In creating my plein air canvases, I've traveled far and wide. My journeys have allowed me to see world-famous landmarks and simple small towns, often within the same day. In the companion volume to this book, *Thomas Kinkade's Romantic Europe*, my travels on that continent led to plein air paintings ranging from a charming cottage in a small British village, to an ancient castle ruin, to the Grand Canal of Venice.

In America, I've been similarly inspired by many notable landmark settings and equally impressed with the small towns of our land—the hidden landmarks often overlooked by the hurried traveler. Although I love to visit San Francisco and paint the Golden Gate Bridge, I also like to cruise along seldom-traveled side roads and quiet country lanes. Big cities, small towns, mountain vistas, waterfronts—they all delight me with their unique charm.

As you travel with me across this great land of ours, I hope you're able to reap in some measure the same joy I received as I painted these scenes, most of which are examples of my plein air work, presented for the first time in book form.

Now, come chase the horizon with me.

THOMAS KINKADE

Liberty Plaza, Philadelphia

When I travel, I enjoy visiting places with great historic significance.

It's a sobering feeling to stand where great men and women of the past have stood as they made history through their courageous deeds. Such is the case at Liberty Plaza in Philadelphia. This stately building is where our Declaration of Independence was signed by 56 brave men. Those men stood on these grounds, they walked this same path, and here they participated in an event that would cost some of them their lives or their fortunes—all in the cause of freedom. These were men who gave birth to a nation. And it was an honor to stand in front of this historic building and consider the miracle that had transpired within its walls more than two hundred years ago.

When Freedom from her mountain-height
 Unfurled her standard to the air,
She tore the azure robe of night,
 And set the stars of glory there.
She mingled with its gorgeous dyes
 The milky baldric of the skies,
And striped its pure, celestial white
 With streakings of the morning light.

Flag of the free heart's hope and home!
 By angel hands to valour given!
Thy stars have lit the welkin dome,
 And all thy hues were born in heaven.
Forever float that standard sheet!
 Where breathes the foe but falls before us,
With Freedom's soil beneath our feet,
 And Freedom's banner streaming o'er us?

JOSEPH RODMAN DRAKE
"The American Flag"

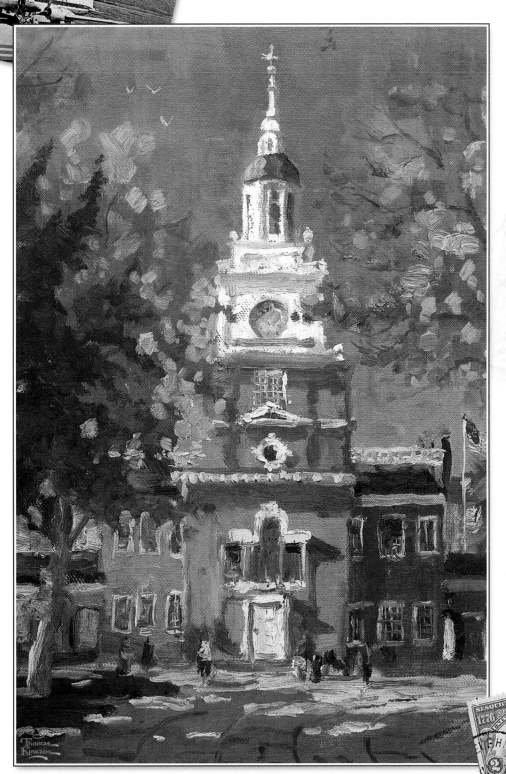

My country, 'tis of thee,
Sweet land of liberty,
Of thee I sing:
Land where my fathers died,
Land of the pilgrims' pride,
From every mountain-side
Let freedom ring.

Our fathers' God, to thee,
Author of liberty,
To thee we sing;
Long may our land be bright
With freedom's holy light
Protect us by thy might
Great God, our King!

SAMUEL FRANCIS SMITH

Liberty, when it begins to take root,
is a plant of rapid growth.

GEORGE WASHINGTON

The Star-Spangled Banner

Oh, say, can you see,
* by the dawn's early light,*
What so proudly we hailed
* at the twilight's last gleaming,*
Whose broad stripes and bright stars,
* thro' the perilous fight,*
O'er the ramparts we watched,
* were so gallantly streaming?*
And the rockets' red glare,
* the bombs bursting in air*
Gave proof thro' the night
* that our flag was still there.*
Oh, say, does that
* star-spangled banner yet wave*
O'er the land of the free
* and the home of the brave?*

FRANCIS SCOTT KEY

The Declaration of Independence
of the Thirteen Colonies
Action of the Second Continental Congress,
July 4, 1776
The unanimous Declaration of the thirteen
United States of America

When in the Course of human events,
it becomes necessary for one People to dissolve
the Political Bands which have connected them
with another, and to assume among the Powers
of the Earth, the separate and equal Station
to which the Laws of Nature and of Nature's
God entitle them, a decent Respect to the
Opinions of Mankind requires that they should
declare the causes which impel them to the
Separation.

We hold these Truths to be self-evident,
that all Men are created equal, that they are
endowed by their Creator with certain
unalienable Rights, that among these are Life,
Liberty, and the Pursuit of Happiness. That to
secure these Rights, Governments are instituted
among Men, deriving their just Powers from
the Consent of the Governed. That whenever
any Form of Government becomes destructive
of these Ends, it is the Right of the People to
alter or to abolish it, and to institute new
Government, laying its Foundation on such
Principles and organizing its Powers in such
Form, as to them shall seem most likely to
effect their Safety and Happiness...

What Happened to the 56 Signers of the Declaration of Independence?

Five signers were captured by the British and brutally tortured as traitors. Nine fought in the War for Independence and died from wounds or from hardships they suffered. Two lost their sons in the Continental Army. Another two had sons captured. At least a dozen of the fifty-six had their homes pillaged and burned.

What kind of men were they? Twenty-five were lawyers or jurists. Eleven were merchants. Nine were farmers or large plantation owners. One was a teacher, one a musician, and one a printer. These were men of means and education, yet they signed the Declaration of Independence, knowing full well that the penalty could be death if they were captured.

In the face of the advancing British Army, the Continental Congress fled from Philadelphia to Baltimore on December 12, 1776. It was an especially anxious time for John Hancock, the President, as his wife had just given birth to a baby girl. Due to the complications stemming from the trip to Baltimore, the child lived only a few months.

William Ellery's signing at the risk of his fortune proved only too realistic. In December 1776, during three days of British occupation of Newport, Rhode Island, Ellery's house was burned, and all his property destroyed.

Francis Lewis also had his properties destroyed. The enemy jailed his wife for two months, that and other hardships from the war affected her health so much that she died only two years later.

"Honest John" Hart, a New Jersey farmer, was driven from his wife's bedside when she was near death. Their thirteen children fled for their lives. Hart's fields and his grist mill were laid waste. For over a year he eluded capture by hiding in nearby forests. He never knew where his bed would be the next night and often slept in caves.

When he finally returned home, he found that his wife had died, his children disappeared, and his farm and stock were completely destroyed. Hart himself died in 1779 without ever seeing any of his family again.

Such were the stories and sacrifices typical of those who risked everything to sign the Declaration of Independence. These men were not wild-eyed, rabble-rousing ruffians. They were soft-spoken men of means and education. They had security, but they valued liberty more. Standing tall, straight, and unwavering, they pledged:

"For the support of this declaration, with a firm reliance on the protection of the Divine Providence, we mutually pledge to each other, our lives, our fortunes, and our sacred honor."

Are there any among us who would do likewise?

AUTHOR UNKNOWN

Skating in the Park

A highlight of any trip to New York City is a romantic hansom cab ride through Central Park.

On this particular brisk January evening, my wife, Nanette, and I were snuggled together as the driver pointed out an occasional point of interest. As we rounded a brightly lit bend, the cabby stopped and announced proudly, "There she is! Wollman Rink."

I suppose to some people winter in New York City can seem less than desirable, but for Nanette and me, the sight was unreservedly beautiful. We both wanted to abandon the cab, don skates, and join in the fun. Instead, I painted the scene and to this day, whenever I look at "Skating in the Park," I'm reminded of that crisp, special evening.

Many of New York's pretensions are absurd, as every sensible person knows; but it has a right to boast of Central Park (and it does, too) for it is indeed an honor and a glory.

JUNIUS HENRI BROWNE
The Great Metropolis

[Central Park] throughout is a single work of art.

FREDERICK OLMSTEAD

There is something about this ceaseless buzz, and hurry, and bustle, that keeps a stranger in a state of unwholesome excitement all the time, and makes him restless and uneasy, and saps from him all capacity to enjoy anything or take a strong interest in any matter whatever—a something which impels him to try to do everything, and yet permits him to do nothing.

MARK TWAIN
Travels with Mr. Brown

It couldn't have happened anywhere but in little old New York.

O. HENRY

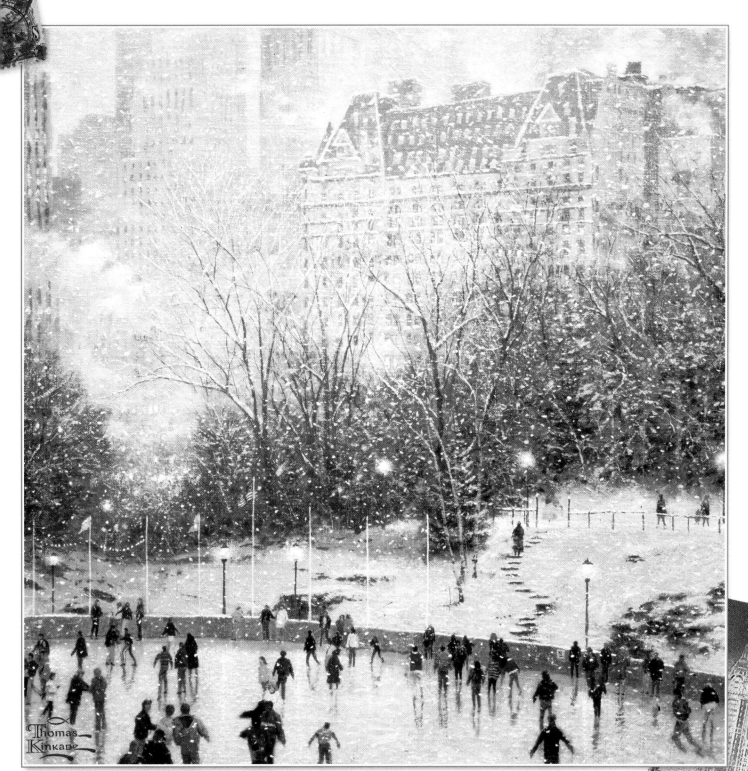

Block Island

This beautiful site is just twelve miles off the coast of Rhode Island and is accessible by a one-hour ferry ride.

Here I found rugged bluffs, miles of sandy beaches, and a rolling verdant landscape. The island's one town, New Shoreham, was incorporated in 1672 and takes pride in being the smallest town in the smallest state in America.

"Block Island" is a study of resolute courage and dignity. A lone ship sets out on its voyage to an unknowable destination, led away from danger by the stoic lighthouse. Poised between the last outcroppings of land and the vast expanse of ocean, the lighthouse has become a profound symbol of human life, poised as it is between the transitory and the eternal.

Of all the islands that lie off the coast of the United States, the most interesting, to my mind, is Block Island. It lies at the junction of Long Island Sound and Narragansett Bay, and is washed by those waters of the Atlantic which are perpetually blue…At its northern extremity, where stands a double light-house, a sandy bar shoots out for a mile and a half under water upon the end of which the oldest inhabitants of the island allege they have gathered berries.

SAMUEL ADAMS DRAKE
Nooks and Corners of the New England Coast, 1875

The great revolving light on the cliff at the channel flashed warm and golden against the clear northern sky, a trembling, quivering star of good hope.

L.M. MONTGOMERY

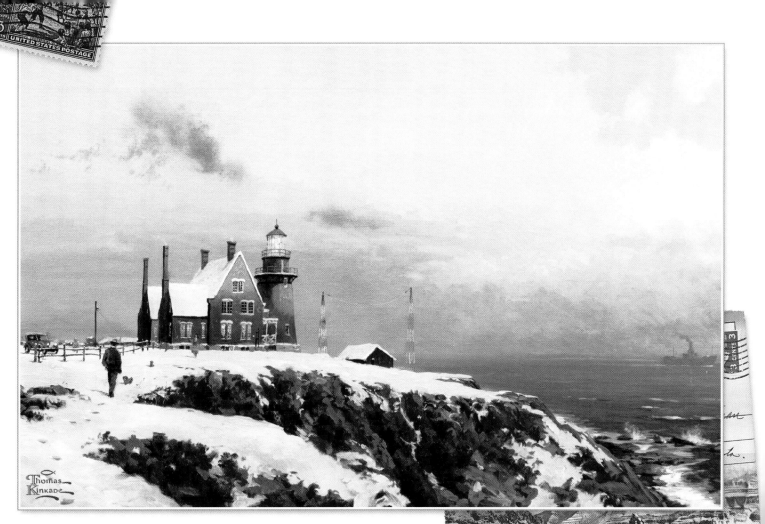

Block Island

Steadfast, serene, immovable, the same,
Year after year, through all the silent night
Burns on forevermore that quenchless flame,
Shine on that inextinguishable light!

HENRY WADSWORTH LONGFELLOW
"The Lighthouse"

The most obvious attraction of our little island...is
its sheer beauty. The stone walls and rambling
roses, the vistas of land and sea, the sweep of
Crescent Beach, the pocket beaches caught between
pounding surf and steep bluff—all are unforgettable.

AUTHOR UNKNOWN

The Lights of Home

In this painting I've attempted to render an epic subject on a miniature scale.

I've portrayed a grandiose two-story Victorian home, flanked by a rustic workshop and barn with the farmer's fields stretching away under a blanket of snow. Inside the warm house, I can imagine the farmer stoking the fire and settling down to pour over a pile of seed catalogs for the approaching spring. His wife emerges from the kitchen where she has just checked her pies in the oven—they need another five minutes—and surveys the blocks she's laid out for her log cabin quilt. Her husband looks up from the catalogs, smells the pies—apple, he guesses—and exchanges knowing glances with his wife.

All is well on this New England farm tonight.

'Tis the bright and joyous season,
Ever fraught with glee and mirth,
Bringing happiness and plenty
To the glad and grateful earth,
And a ring of loving faces round the
Warm and sparkling hearth.

And the long bright winter evening
Passes merrily away,
While the quaint and varying shadow
On the ceiling dance and play,
And each radiant face grows brighter
In the firelight's rosy ray.

FLORENCE PERCY

Keep the home fires burning…

LENA GILBERT FORT

268 HEAD 'ER FER FLORIDY!

Crank up the Lizzy, an' all git aboard,
We're goin' down south, so hurry up an' load!
I know she rattles, an' the radiator leaks!
But she'll git us thar safe, even if she squeaks!
Git the axe an' saw, an' the big fryin' pan;
An' the tent an' pegs. An' oh, my lan'!
Don't forgit the matches, an' the ole tire pump!
Hustle around now, an' keep on the jump!
The weather-man says, that's a blizzard comin';
So crank up the Lizzy an' keep 'er a-hummin'!
Head 'er fer Floridy, as fast as we can go:
An' we'll beat that blizzard, first thing we know!
We'll pitch our tent, by a runnin' stream,
An' the rest of the winter, 'll be one long dream!

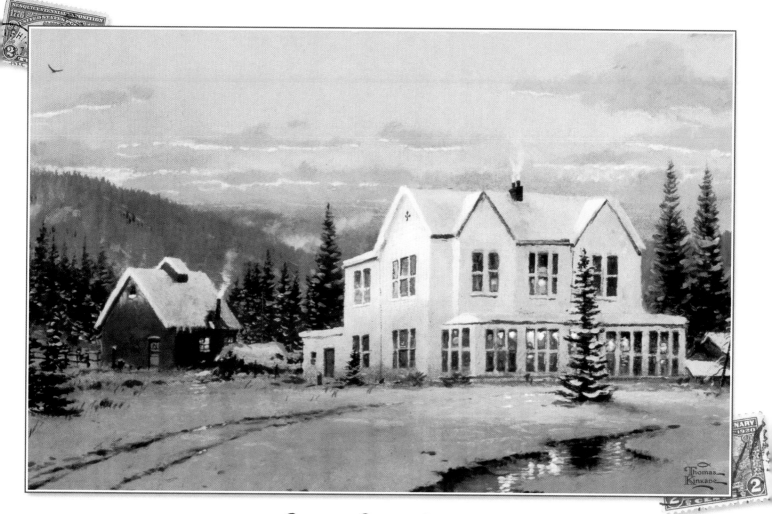

The Lights of Home

Be it ever so humble, there's no place like home.

JOHN PAYNE

It takes a heap o' livin' in a house t' make it home.

EDGAR GUEST

The Water Tower, Chicago

During the harsh winter months, you can feel the cold wind come rushing down Chicago's Michigan Avenue from the lake.

Yet the tourists never seem to mind, they come to see the landmark Chicago Water Tower, erected in 1869. Just two years later, the Chicago fire consumed the city—except for the Water Tower, built of native Joliet limestone blocks. It alone survived, inspiring the citizens to rebuild their town bigger and better than ever. Now, more than a century later, Chicago has arisen from the ashes to be one of our greatest American cities. Chicago, Chicago, that toddlin' town…

…Chicago where…there is romance and big things and real dreams…

CARL SANDBURG
Chicago Poems, 1916

Hog Butcher for the World,
Tool Maker, Stacker of Wheat
Player with Railroads and
 the Nation's Freight Handler;
Stormy, husky, brawling,
City of the Big Shoulders.

CARL SANDBURG
Chicago Poems, 1916

I adore Chicago. It is the pulse of America.

SARAH BERNHARDT

I have struck a city—a real city—and they call it Chicago…

RUDYARD KIPLING, 1891

She is always a novelty; for she is never the Chicago you saw when you passed through the last time.

MARK TWAIN
Life on the Mississippi, 1883

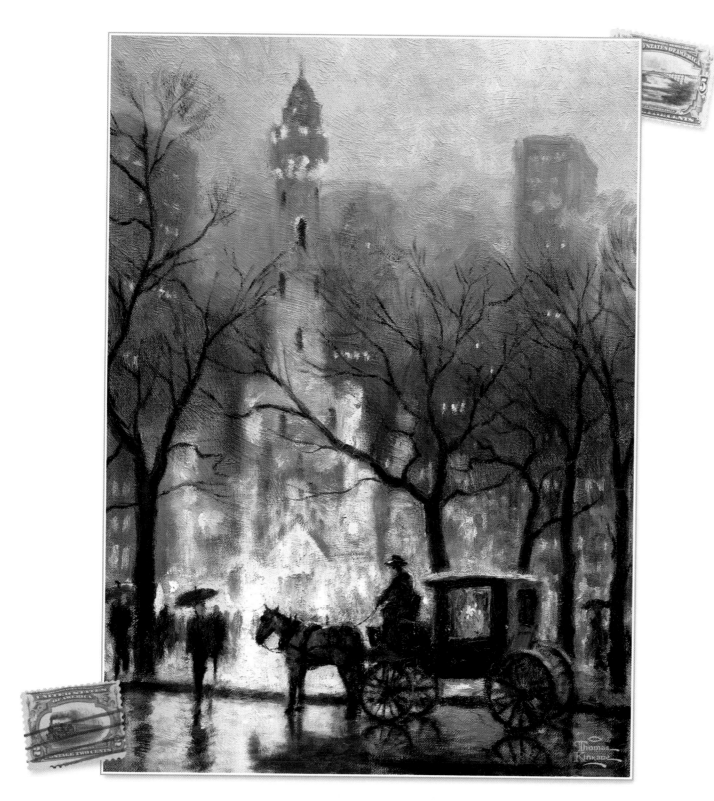

Chicago is a city of contradictions, of private visions haphazardly overlaid and linked together. If the city was unhappy with itself yesterday—and it invariably was—it will reinvent itself today.

PAT COLANDER

Chicago is an October sort of city even in spring.

NELSON ALGREN

When Professor Goldwin Smith was preparing for his voyage to America, Mr. Richard Cobden said to him, "See two things in the United States, if nothing else—Niagra and Chicago." Professor Smith acted on this advice, and, while visiting Chicago, acknowledged that the two objects named by his friend were indeed the wonders of North America.

JOHN S. WRIGHT
Chicago: Past, Present, Future, 1870

Chicago is at the base of a congress of lakes—Superior, Huron and Michigan—which, on the map, makes it look like the sensitive area of some vital organ—lungs or heart or liver drawing in or giving out blood—a meeting of waterways, airways and railways—the pulse of the continent.

PAUL STEPHEN and HOGARTH SPENDER

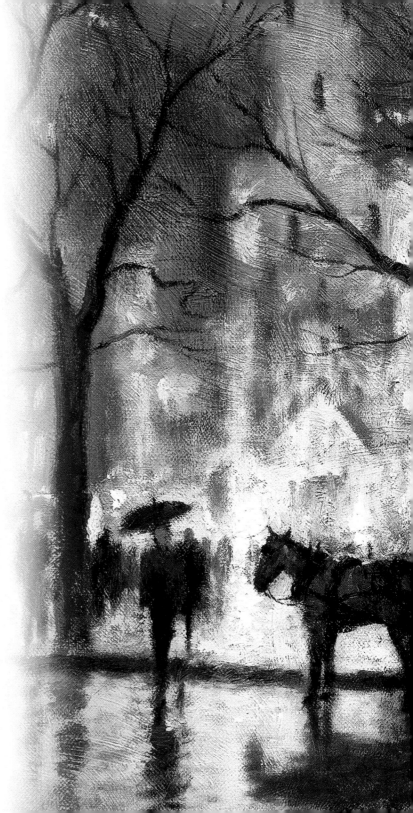

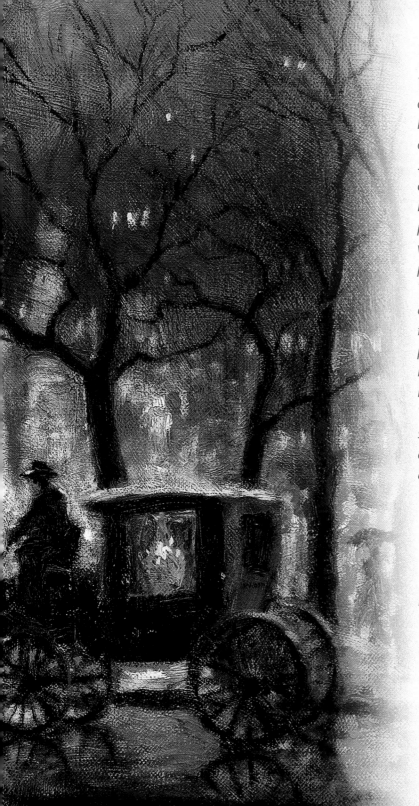

The great World's Fair was held in Chicago in 1893, celebrating the four hundredth anniversary of the landing of Columbus. It was a magnificent advance on the famous Centennial of 1876. Costing over $20,000,000, its ideal edifices satisfied all standards of taste and beauty. Enormous buildings were erected, but instead of being merely useful, the most elaborate pains were taken with their architecture. The exterior was a white composition known as staff, being principally plaster of Paris, which looked like marble. The decorations, mural and statuary, were elaborate and artistic. The grounds were laid out with lagoons, fountains, and all that landscape gardening could produce. The whole was a veritable fairyland. At night the buildings and lagoons were lighted up by electricity and the artistic effect was magnificent. The exhibits were complete and comprehensive, showing all that the world could offer in the arts and sciences. Foreigners were amazed at the display, and Americans no less.

EDITED BY HUBERT BANCROFT, 1902
The Great Republic by Master Historians, Vol. III

It's a beautiful day in Chicago!

DON MCNEIL
Traditional opening for "The Breakfast Club"
Chicago-based variety show 1933-68

Plaza Lights, Kansas City

Kansas City is such a wonderfully typical American city—truly the heart of the country.

And perhaps the most memorable place in Kansas City is historic Country Club Plaza. With its old-world European architecture, you may have a hard time distinguishing this famous shopping and entertainment neighborhood from those in Barcelona, Rome, or Lisbon. Yet this popular district was designed in 1922 as America's first suburban shopping district. The wet-with-rain streets and ever-threatening clouds didn't dampen the spirits of locals and tourists alike who made their way along 47th Street on this September afternoon.

A signalman in a tower, the outpost of Kansas City, keeps his place at a window with the serenity of a bronze statue on a dark night when lovers pass whispering.

CARL SANDBURG
Cornhuskers, 1918

I think I should like to go back to Kansas.

DOROTHY
The Wizard of Oz

…and my Kansas fields,…devoting the whole identity, without reserving an atom, Pour in! whelm that which asks, which sings, with all, and the yield of all.

WALT WHITMAN
Leaves of Grass, 1900

We then had a good view of all there is to Kansas City. It is a most singular location for a town, being a gathering together of hills, high and steep. Houses of very limited dimensions are perched upon all the highest points. They have usually a porch over the door, or light piazza.

SARAH ROBINSON, 1855

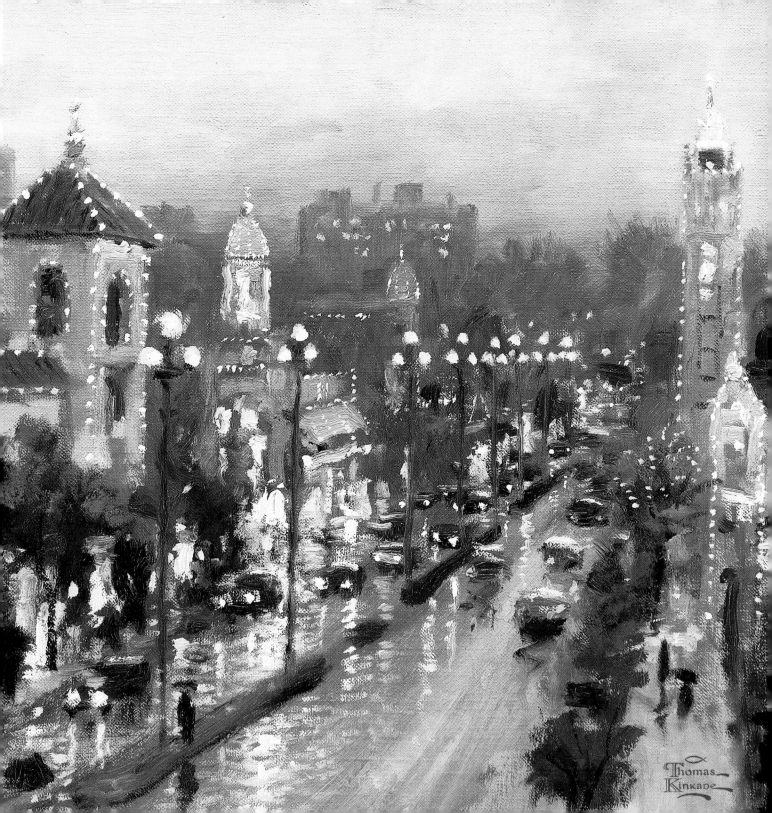

Thistle Hill

This historic Texas home near Ft. Worth has a monumental dignity.

It's one of the last surviving mansions of the Texas cattle baron years and one of the few remaining examples of Georgian Revival architecture in the Southwest.

When that direct Texas sun burnishes the brick of Thistle Hill, the structure rises up most impressively from the plain. The light was perfect. I chose my spot, set up my easel, and painted to my heart's content.

God bless you, Texas! And keep you
brave and strong,
That you may grow in power and worth,
throughout the ages long.

WILLIAM J. MARSH and
GLADYS YOAKUM WRIGHT

Mind not me—mind—the entrenchments….I tell what I knew in Texas in my early youth.

WALT WHITMAN
Leaves of Grass, 1900

Texas is not a state—it's a state of mind.

JOHN STEINBECK

Mrs. Scott's formal gardens lay in the southeast corner of the property…Larkspur, violets and petunias would have bloomed in the beds, and ivy covered the walls of the house itself.

JUDY ALTER
Thistle Hill: The History and the House

A lattice-covered pillar-lined walk forty feet long, the pergola sits to the west of the mansion, beyond the porte cochere. Mrs. Scott had jasmine and climbing roses planted to almost cover the frame of the structure.

JUDY ALTER
Thistle Hill: The History and the House

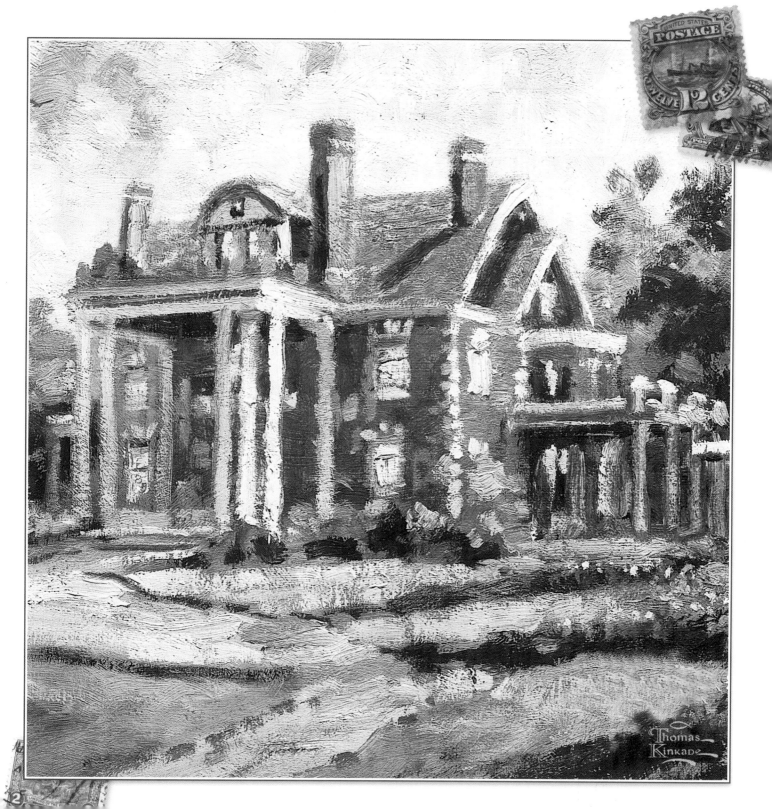

High Country Camp

The scene is filled with anticipation.
Horses at the ready: calm, but full of strength.

Mountains waiting silently above, as they have for centuries. There is no hurry here. The buildings are brown, dusty, and dry, almost colorless. This camp is an intimate refuge among the massive pines, nestled as it is in the mountains. This is no doubt the same picture that could have been painted at this very spot a century ago. The remote places where time has stood still in America are diminishing too quickly. This is one of those rare places that remains untouched.

Two or three times a year, usually in the fall, when it blew long and hard from the northwest, it broke in over…the country as far as the eye could reach. Then the high causeways were the refuge of everything that lived in the fields; hares, mice, foxes, and partridges huddled there…

JACOB A. RIIS
The Making of an American, 1901

…it is the life of men who live in the open, who tend their herds on horseback, who go armed and ready to guard their lives by their own prowess…

THEODORE ROOSEVELT
Ranch Life and the Hunting-Trail, 1896

When you have lived out in the West,
 Till it becomes a part of you,
And you've a feeling in your breast
 No other spot on earth will do;
When you can call the desert home,
 And love the ranges vast and drear,
Then every butte and rocky dome,
 And stretch of sage will grow more dear.

When all God's great out-of-doors
 You worship with a new delight;
When rocky ridge and canyon floors,
 Show added wonders day and night;
When wide, free plains seem reaching out
 To welcome you with open arms,
You will have learned, without a doubt,
 The secret of the great West's charms.

A. E. BRININSTOOL
The West

…cowboys from neighboring ranches will ride over, looking for lost horses, or seeing if their cattle have strayed off the range.

THEODORE ROOSEVELT
Ranch Life and the Hunting-Trail, 1896

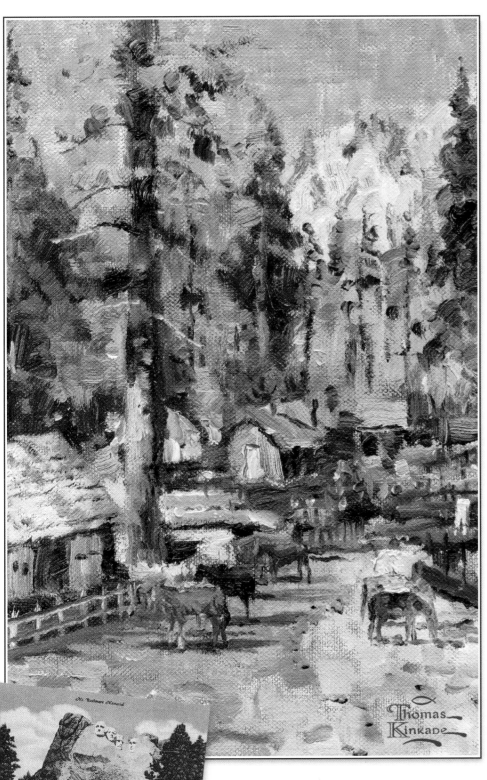

My fathers sleep on the sunrise plains,
 And each one sleeps alone.
Their trails may dim to the grass and rains,
 For I choose to make my own.
I lay proud claim to their blood and name,
 But I lean on no dead kin;
My name is mine, for the praise or scorn,
And the world began when I was born
 And the world is mine to win.

They built high towns on their old log sills,
 Where the great, slow rivers gleamed,
But with new, live rock from the savage hills
 I'll build as they only dreamed.
The smoke scarce dies where the trail camp lies,
 Till the rails glint down the pass;
The desert springs into fruit and wheat
And I lay the stones of a solid street
 Over yesterday's untrod grass.

The sunrise plains are a tender haze
 And the sunset seas are gray,
But I stand here, where the bright skies blaze
 Over me and the big today.
What good to me is a vague "maybe"
 Or a mournful "might have been,"
For the sun wheels swift from morn to morn
And the world began when I was born
 And the world is mine to win.

BADGER CLARK
The Westerner

High Country Meadow

There is a deeply beautiful glow to the Cottonwood tree when the sun singles it out.

This meadow seems particularly favored today. Though the sky is darkening, the trees hold the light like they are burning from within. This radiance has attracted me to paint from this particular angle. In the cool air is the clear scent of country air. The slight rush of the water serenades me as I paint. I could stay in this spot for hours, but as the sun changes, the luminance leaves and a chill dances in the air.

Echoes of tinkling bells linger there still, but they do not call up memories of green meadows and summer fields; they proclaim the home-coming…

JACOB A. RIIS
How the Other Half Lives, 1890

…great billowy masses of reeds ever bent and swayed under the west wind that swept over the meadows. They grew much taller than our heads, and we boys loved to play in them…

JACOB A. RIIS
The Making of an American, 1901

The Cowboy's Prayer

*Oh Lord, I reckon I'm not much just by myself.
I fail to do a lot of things I ought to do.
But Lord, when trails are steep and passes high,
Help me to ride it straight the whole way through.
And when in the falling dusk I get the final call,
I do not care how many flowers they send—
Above all else the happiest trail would be
For You to say to me, "Let's ride, My friend."
Amen*

ROY ROGERS, EPITAPH
Sunset Hills Memorial Park, Apple Valley, California

He lets me rest in the meadow grass and leads me beside the quiet streams…

THE BOOK OF PSALMS

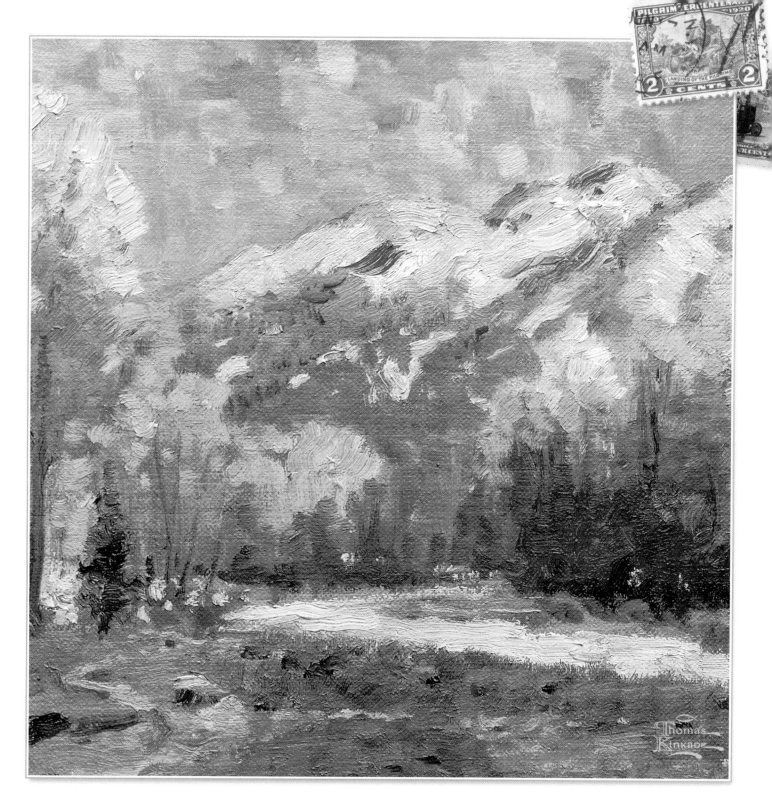

The Old Mission, Santa Barbara

Santa Barbara is often called "The American Riviera."

Yet even with its many art galleries and theatres, the most popular site in the city seems to be the Old Mission. The graceful and lovely Spanish architecture of the mission stands proud, gleaming in the golden light of a California sunset. Since 1786 the mission has watched the changing environs of Santa Barbara. Yet its beauty is unmatched by the architectural latecomers to the area. Perhaps it's because the mission seems to radiate a spiritual beauty in addition to its esthetic splendor. Would that every town could have a Mission Santa Barbara.

…where surf has come incredible ways out of the splendid west, over the deeps. Light nor life sounds forever; here where enormous sundowns flower and burn through color to quietness.

ROBINSON JEFFERS

The ringing of the old Spanish bells, the hum of the humming birds and bees among the flowers, the pigeons cooing in the rafters, the smiling faces of the monks and students in their brown-tasseled gowns, as they pass on their way to mass, make an indelible impression...I could again see them and feel their warm greetings and pass some more delightful days with them at the mission.

SAMUEL NEWSOM
"The Santa Barbara Mission"

The waves come in slowly, vast and green, curve their translucent necks, and burst with a surprising uproar, that runs, waxing and waning, up and down the long key-board of the beach. The foam of these great ruins mounts in an instant to the ridge of the sand glacis, swiftly fleets back again, and is met and buried by the next breaker.

ROBERT LOUIS STEVENSON

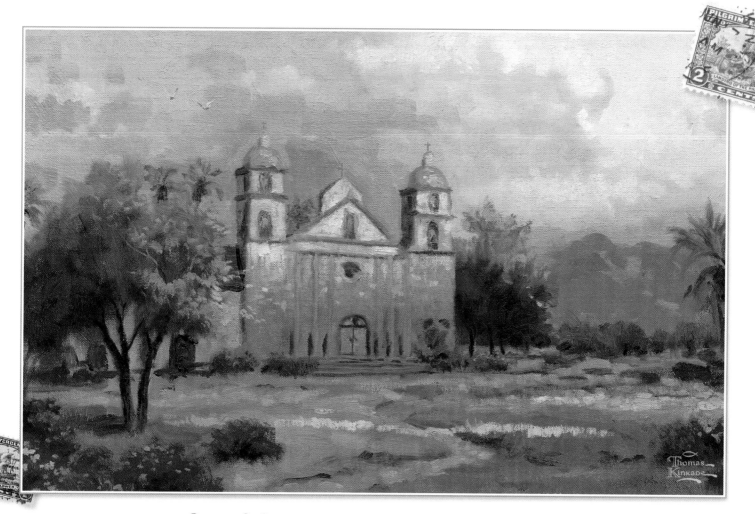

The Old Mission, Santa Barbara

A summer land south-bound by summer seas;
North-rimmed with rugged mountains;
And all between a ravishment of trees
And vines and flowers and fountains.

RUTHELLA BOLLARD
"Santa Barbara"

But oh! how I would like to take my mother, Mary
Hoyt, in a railroad car out to California, to Santa
Barbara…among the vineyards of grapes, the
groves of oranges, lemons and pomegranates.

EDWARD BOK
The Americanization of Edward Bok

Rainy Day in Carmel

Carmel-by-the-Sea has been influential in many of my paintings.

I've used some of the village's most charming houses as models for my popular cottage paintings. It was natural then that as I began my plein air work, I'd return to Carmel for inspiration. I'm not alone in my appreciation for this delightful resort—I'm told that the scenic central coast of California is the most popular travel destination in America. Tourists love to walk the length of Ocean Avenue and peek in the many quaint shops that line the street. Along the way, they'll stop for a cup of warm cocoa or a cappuccino, especially on a rainy winter's day such as this. As they continue their stroll west down the avenue, they'll arrive at the beach and perhaps wade in the chilly blue surf.

Is it any wonder that I return again and again to Carmel? It's been the perfect source of inspiration for artists, poets, and musicians for many years. Some, such as poet Robinson Jeffers, have become synonymous with this part of the Monterey Peninsula as they've so effectively captured its beauty in their work.

*It is only a little planet
But how beautiful it is.*

ROBINSON JEFFERS
"The Beginning and the End"

Carmel, the enchanted village…

HERB CAEN

The one common note of all this country is the haunting presence of the ocean. A great faint sound of breakers follows you high up into the inland canyons; the roar of water dwells in the clean empty rooms…as in a shell upon the chimney. Go where you will, you have but to pause and listen to hear the voice of the Pacific.

ROBERT LOUIS STEVENSON

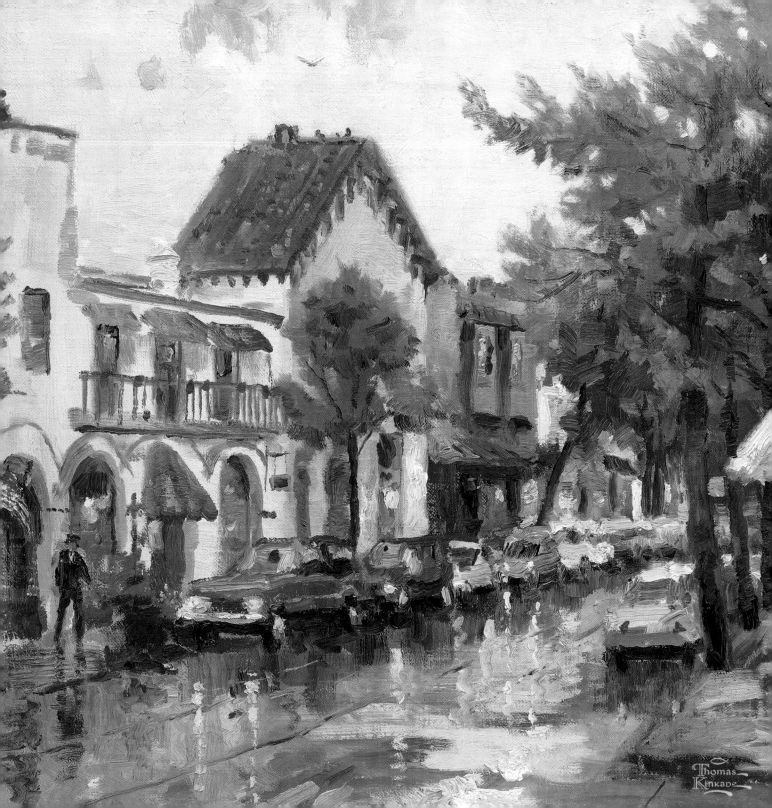

San Francisco, View from Coit Tower

San Francisco is one of my favorite places in the world.

And although I live only two hours away and know "The City" like my own hometown, I'm still awed on my every visit. As an artist, it's not hard to find a San Francisco perspective that's worthy of capturing on canvas. In this case, the view is from Coit Tower, high atop Telegraph Hill where you can see an incredible panoramic view of San Francisco. On this day, I chose the angle that offers a look at the city, the bay, and the majestic Golden Gate Bridge.

Every traveler must visit San Francisco at least once. And having done so, it will become clear why San Francisco's most beloved newspaper columnist, the late Herb Caen, insisted, "don't call it 'Frisco."

Telegraph Hill, where you can't send a telegram—but where you can get the message of San Francisco merely by looking.

HERB CAEN

The true lover of San Francisco can list a thousand sights, sounds, and smells that his mind holds in readiness to spring as a quick, stabbing reminder to him, wherever he is, that San Francisco is his own city.

JOSEPH HENRY JACKSON

San Francisco is a city set to music and the words "San Francisco" are part of the melody. Speak them, my friend. Speak them softly, as San Franciscans do. The padres, the missions, the haciendas, the '49ers; the gentle fog, the bright sun, the sea; the past, the present, and the future of this warm and friendly city—all are in those words. Speak those gentle syllables, good friend—San Francisco. Now say "Frisco." Do you see what we mean?

CYRIL WRIGHT

When I awoke in the morning, and looked from my windows over the city of San Francisco, with its storehouses, towers, and steeples; its court-houses, theatres, and hospitals; its daily journals; its well-filled learned professions; its fortresses and fighthouses; its wharves and harbor, with their thousand-ton clipper ships, more in number than London or Liverpool sheltered that day, itself one of the capitals of the America Republic, and the sole emporium of a new world, the awakened Pacific—when I saw all these things, and reflected on what I once was and saw here, and what now surrounded me, I could scarcely keep my hold on reality at all, or the genuineness of anything, and seemed to myself like one who had moved in "worlds not realized."

RICHARD HENRY DANA
Two Years Before the Mast and Twenty-Four Years Later

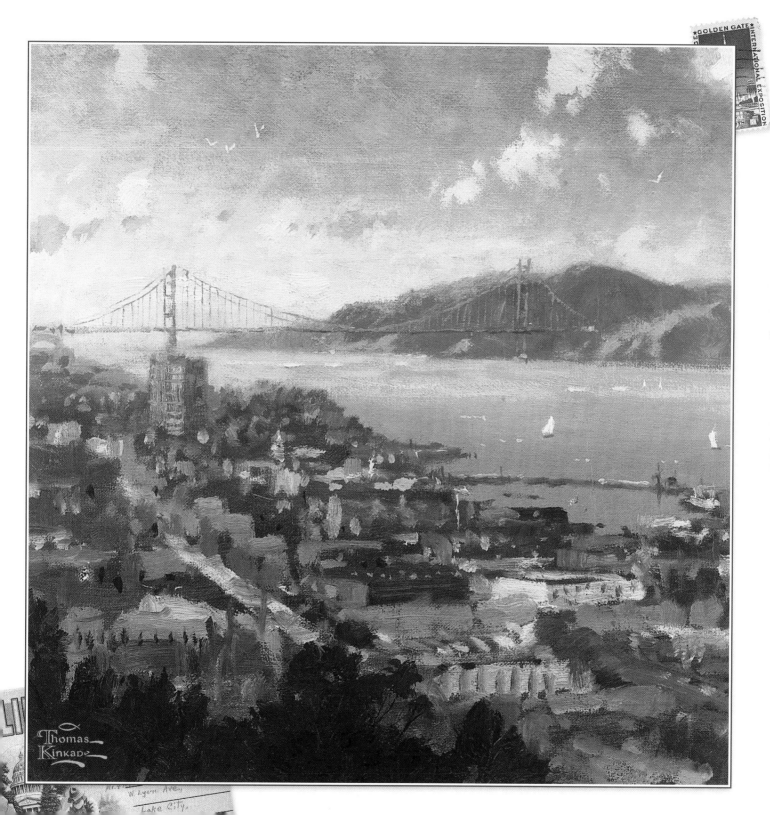

Thomas Kinkade

W. Lyon Ave,
Lake City,

Chinatown, San Francisco

On a magical rainy San Francisco day I set up my easel on busy Grant Avenue outside my favorite Chinatown eatery, the Far East Café.

Leaning out from under an awning where I was trying to keep dry, I recorded the glistening street and brilliant lights of one of San Francisco's most interesting districts. The history of Chinatown seems to permeate its present-day character. The small shops and numerous street vendors seem to be just as one would imagine them to have been fifty years ago. The residents of Chinatown, many of whom have lived here all their lives, guard their heritage vigorously. Chinese is still the language of choice—both spoken and written—as evidenced by the signs and by the lively conversations engaged in by passersby as I painted.

San Francisco is among the most beautiful cities on earth. And Chinatown is a special part of the beauty—and one of the reasons I love the City by the Bay.

Wherever, in any channel of the Seven Seas, two world-wanderers met and talked about the City of Many Adventures, Chinatown ran like a thread through their reminiscences.

WILL IRWIN

There is no night or day in the business of Chinatown. And it takes but little imagination to smell the sweet, cloying vapors of opium drifting from places below sidewalk level, or to hear, coming from behind closed doors, the rattle and clatter of fan-tan chips and mah-jongg tiles.

SAMUEL DICKSON
San Francisco Is Your Home, 1947

Midsummer October in Chinatown. The smell of fish and poultry hanging powerfully in the heavy air. Girls in dark glasses and Bermuda shorts wandering along Grant Avenue, wrinkling their noses and staring through a dirty window as a hung dangling octopus stared back with all its tentacles.

HERB CAEN
Only in San Francisco

I find myself walking along a narrow street in a jungle of Chinese lettering, interpreted here and there by signs announcing Chop Suey, Noodles, Genuine Chinese Store. There are ranks of curio stores, and I find myself studying windows full of Oriental goods with as much sober care as a small boy studying the window of a candy store. The street tempts you along.

JOHN DOS PASSOS
"Chinatown," *Harper's,* 1944

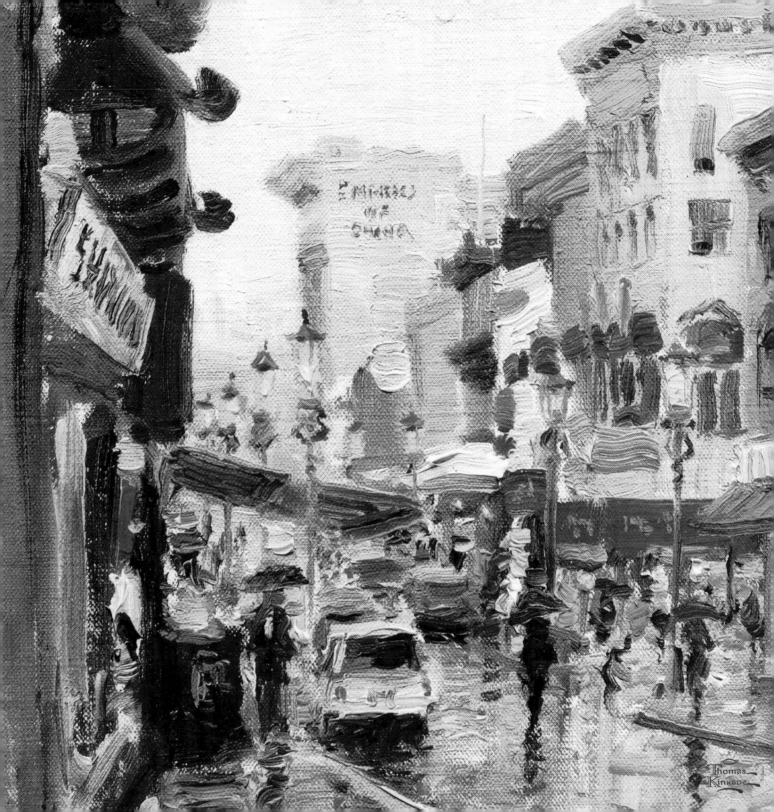

Crater Lake

If you've ever traveled through the northwestern United States, you've seen examples of nature's beauty unlike that of anywhere else.

A good example is in southern Oregon where the velvet blue waters of Crater Lake sit in tranquility surrounded by ancient lush green forests. It's peaceful here—so peaceful that it's breathtaking to remember that this serenity was created by unimaginable violence. This lake, technically a volcanic caldera, was created more than six thousand years ago when 10,000-foot-high Mt. Mazuma erupted and collapsed, sending volcanic ash as far east as Nebraska and carving out this six-mile-wide lake, the deepest in North America.

The nearby Klamath Indians have revered this spot for many generations. They successfully kept its existence a secret to white explorers until 1853, when it was happened upon by three gold prospectors. The trio said it was the bluest lake they'd ever seen and thus named it "Deep Blue Lake." Later it was named "Lake Majestic" until 1869 when it became "Crater Lake."

Today it's still blue, still majestic, and still revered by nature lovers.

Not a foot of the land about the lake had been touched or claimed. An overmastering conviction came to me that this wonderful spot must be saved, wild and beautiful, just as it was, for all future generations, and that it was up to me to do something…The lake ought to become a National Park. I was so burdened with the idea that I was distressed. [For] many hours in Captain Dutton's tent [Dutton was head of a small military party assigned to accompany LeConte], we talked of plans to save the lake from private exploitation. We discussed its wonders, mystery and inspiring beauty, its forests and strange lava structure. The captain agreed with the idea that something ought to be done—and done at once if the lake was to be saved, and that it should be made a National Park.

WILLIAM GLADSTONE STEEL
Founder of Crater Lake National Park

Crater Lake is one of the great natural wonders of this continent.

GIFFORD PINCHOT
On his travels to Crater Lake with John Muir, 1902

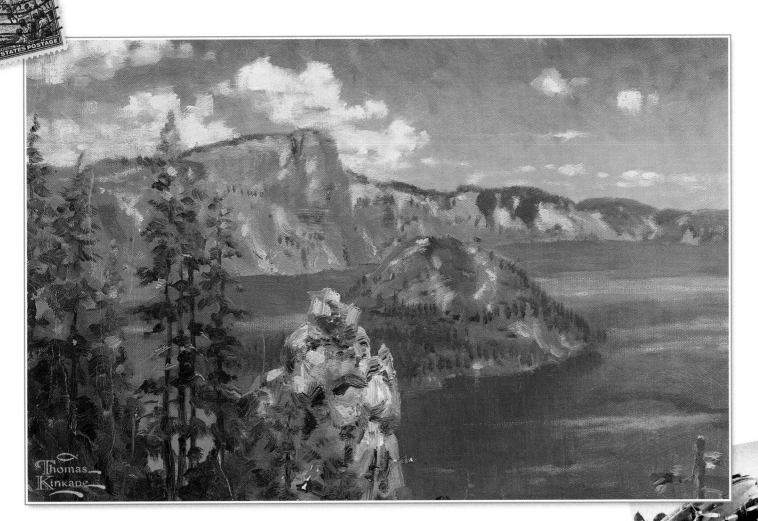

Crater Lake

This is the garden spot of the [Cascade Range Forest] reserve, and no pictures or language can do justice to its charms. It must be seen and felt to be appreciated. Lava [Elk] lake, lying south of the Three Sisters, is one of the most charming and picturesque places I have ever been permitted to gaze upon. There it lies in the wildest depths of the mountains, among snow-covered peaks, rising out of unbroken forests, and the valley to the south of it covered with luxuriant grasses, hills rising and separating grand lakes. Indeed it is a most remarkable region. Guarded on the north by five snow-capped sisters, sentineled on the sides by the Old Bachelor [Mt. Bachelor], Saddle [probably Elk] mountain and numerous buttes, in the south Crater lake, Crescent lake and Diamond peak form a fitting circle…These lakes about 12 miles due south of the Three Sisters, and each over a mile long, do not appear on the recent maps. They are remarkable for having more trout to the square rod than any other body of water in Oregon. They are so numerous that it soon ceases to be sport to catch them.

DR. J. HUNTER WELLS
On an expedition with Judge John B. Waldo, 1891

Pike Place Market, Seattle

The sights and sounds of Seattle are both amazing and unique.

One of the most talked about places in the area is Pike Place Market. This nine-acre community within the city was established in 1907 as a public "farmers' market," making it one of the oldest of these unique marts in the country. With musicians playing and people bustling around, it's an excellent area to soak in the splendor of this fantastic city. And as is frequently the case in the beautiful Northwest, it was raining on the day I set up my portable easel for this scene.

The Market, not Mount Rainier, is Seattle's soul.

MARK TOBEY

…I'll see that you get started in business out West somewhere, maybe Seattle—they say that's a lovely city.

SINCLAIR LEWIS
Babbitt

Seattle: Not a solution to a problem, an alternative to having problems.

ALAN FURST

It will stop raining, won't it?

RICHARD EBERHART

There is probably no city in the Union today so much talked about as Seattle and there is certainly none toward which more faces are at present turned. From every nook and corner of America and from even the uttermost parts of the earth, a ceaseless, restless throng is moving—moving toward the land of the midnight sun and precious gold, and moving through its natural gateway—the far-famed City of Seattle.

The Seattle Daily Times, 1898

Seattle is the result of a patriotic, unselfish, urban spirit which has been willing to sacrifice in order to gain a desired end—the upbuilding of a great city....Seattle has well-paved streets, a thorough and satisfactory street car system, large and handsome business blocks, and residence districts adorned by palatial homes and green and velvety lawns.

DANIEL L. PRATT
"Seattle, The Queen City," *The Pacific Monthly,* 1905

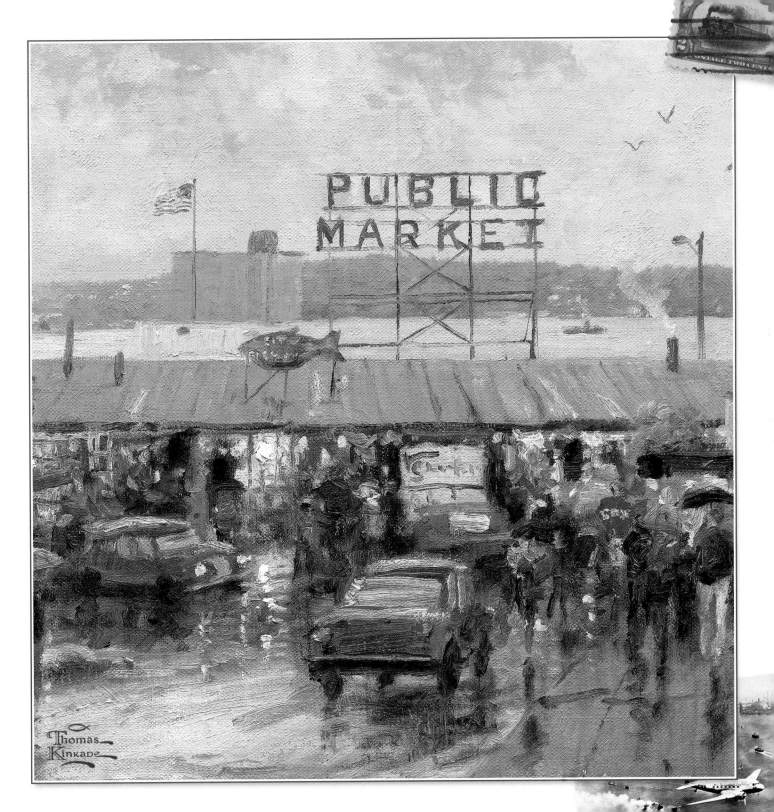

PUBLIC MARKET

Thomas Kinkade

Mount Rainier

Seattle is the perfect place to steal away for an early morning hike.

You may find a view of Mt. Rainier's peak piercing through the clouds with the crisp blue-gray sky perfectly framing its snow-capped peak. The grandeur of this sight, with the morning sunlight glittering off the enormous wonder, is simply breathtaking.

In His hands are the depths of the earth, and the mountain peaks belong to Him…

THE BOOK OF PSALMS

Whether hiking on its flanks, climbing its summit, snowshoeing or cross-country skiing on its slopes, camping along its glacier-fed rivers, photographing wildflower displays in subalpine meadows, or just admiring the view, nearly two million people come to enjoy the grandeur and beauty of Mount Rainier each year.

NATIONAL PARK SERVICE

…to the north and west still, a hundred and fifty miles away, sharp against the sky, stood the grand range of the Cascade Mountains, with the kingliest peaks— Adams, Hood, St. Helens, and Rainier propping up the very heavens. On a bright clear day, this view must be very fine; as it was, we caught but a glimpse or two of it, just enough to make us hunger for more, when the clouds shut in again and we hastened on.

JAMES FOWLER RUSLING, 1877

Far to the south, in the background of the Olympian range, the dim form of Mt. Rainier was seen lifting itself up in the sky.

SANDFORD FLEMING, 1872

For residents of Washington state, particularly of the Puget Sound area, Mount Rainier has long been an icon, a recreational mecca, and spiritual retreat. For more than a hundred miles in any direction, Mount Rainier is the dominant landform on the horizon, providing an almost mystical presence of pristine wilderness right at the urban doorstep.

AUTHOR UNKNOWN

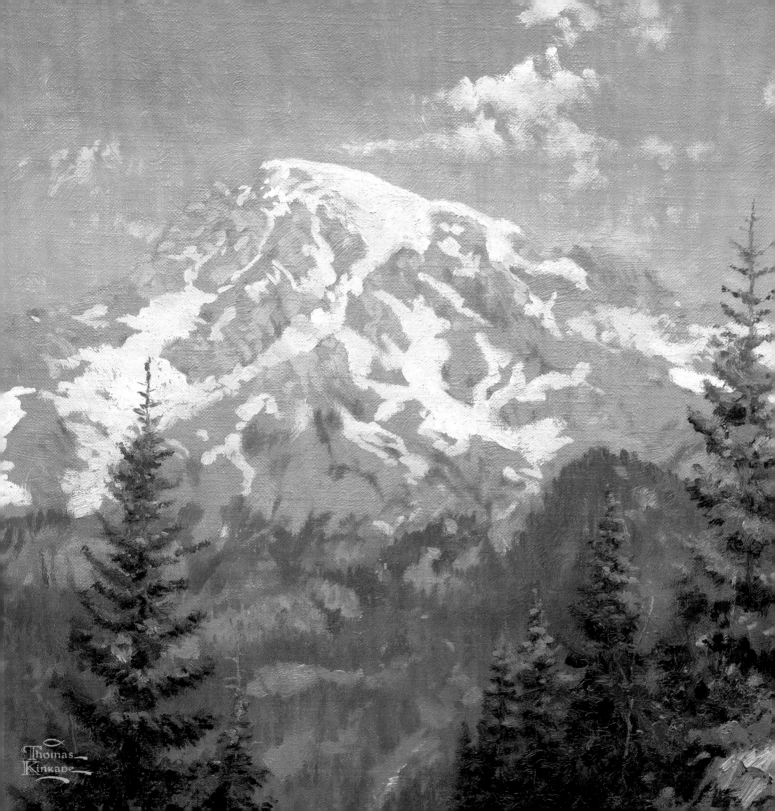

Dawson

The Yukon River with Gold Seekers Landing by Moonlight in 1898.

This work returns me to the beginnings of my career as an artist. Along with "Placerville: Main Street at Dusk 1916," it was my first offering to the print-collecting public. This exciting subject also brings me back to one of my grandest artistic adventures. Some years ago, I packed my paints and took a two-week sketching tour through the far reaches of the Alaskan wilderness. In Dawson, I found not only wilderness, but also an understanding of what it must have been like during the days of the Klondike Gold Rush when thousands of men left their stateside homes and headed "north to Alaska" in search of their fortunes. In April 1897, the population in Dawson was 1,500. By summer it reached 3,500. One year later, between 20,000 and 30,000 gold seekers reached Dawson. Very few, of course, got rich from mining for gold. The wise merchant who sold goods to the prospectors had a better chance of finding prosperity in this frigid land.

As I painted, it was often so cold that the watercolors simply froze. I finally solved that problem by mixing the colors in rubbing alcohol instead of water. I'm grateful for that inspiration; it allowed me to create some canvases that, upon my return, expressed the intense isolation and fragile beauty of that remote, frozen region.

"Why, ain't you heerd?" The old man chuckled quietly. "They-all's gone to Dawson."

"What-like is that?" Bill demanded. "A creek? or a bar? or a place?"

"Ain't never heered of Dawson, eh?" The old man chuckled exasperatingly. "Why, Dawson's a town, a city, bigger'n Forty Mile. Yes, sir, bigger'n Forty Mile."

JACK LONDON
The Faith of Men

I smiled and thought of the friend who wrote me: "So, you're actually going to Dawson and nothing we can say or write will prevent it. Well, willful woman must have her way. I hope you won't regret it." All these thoughts arose in my mind as E_____ and I stood on the deck of the steamer, not watching the disappearing land, but looking eagerly, hopefully forward to that which was to come.

MARY HITCHCOCK
Two Women in the Klondike, 1899

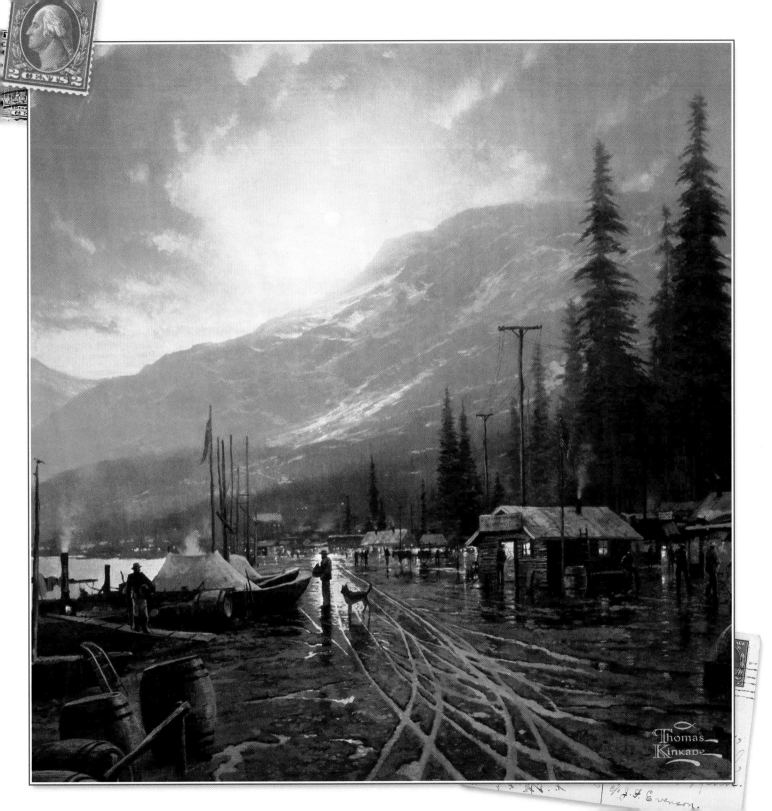

Front Street, Lahaina

There is something exotic about Hawaii that draws visitors time and again to the shores of the islands.

Perhaps it's the calming waves and gentle balmy breezes that we find inviting. Or maybe it's the relaxed Polynesian culture and the friendly Hawaiian people that charm us.

The waterfront such as this one on Front Street in the Maui village of Lahaina, formerly the whaling capital of the central Pacific, is typical of those that offer visitors a soothing retreat, tempting them to stay a while longer than they'd planned. Why hurry home? Let's linger as long as we can. Everything else can wait, except today. Let's enjoy.

For me its balmy airs are always blowing, its summer seas flashing in the sun; the pulsing of its surf is in my ear; I can see its garlanded crags, its leaping cascades, its plumy palms drowsing by the shore, its remote summits floating like islands above the cloud-rack; I can feel the spirit of its woody solitudes, I hear the splashing of the brooks; in my nostrils still lives the breath of flowers that perished twenty years ago.

MARK TWAIN

This is the most magnificent, balmy atmosphere in the world—ought to take dead men out of the grave.

MARK TWAIN

Maui lies between Oahu and Hawaii, and is somewhat larger than the first named island. It contains the most considerable sugar plantations and yields more of this product than any one of the other islands. It is notable also for possessing the mountain of Haleakala, an extinct volcano ten thousand feet high which has the largest crater in the world, a monstrous pit thirty miles in circumference, and two thousand feet deep...In the first place, you must understand that the rainfall varies extraordinarily. The trade wind brings rain; the islands are bits of mountain ranges; the side of the mountain which lies toward the rain-wind gets rain; the lee side gets scarcely any. At Hilo it rains almost constantly; at Lahaina they get hardly a shower a year.

CHARLES NORDHOFF
Northern California, Oregon,
and the Sandwich Islands, 1875

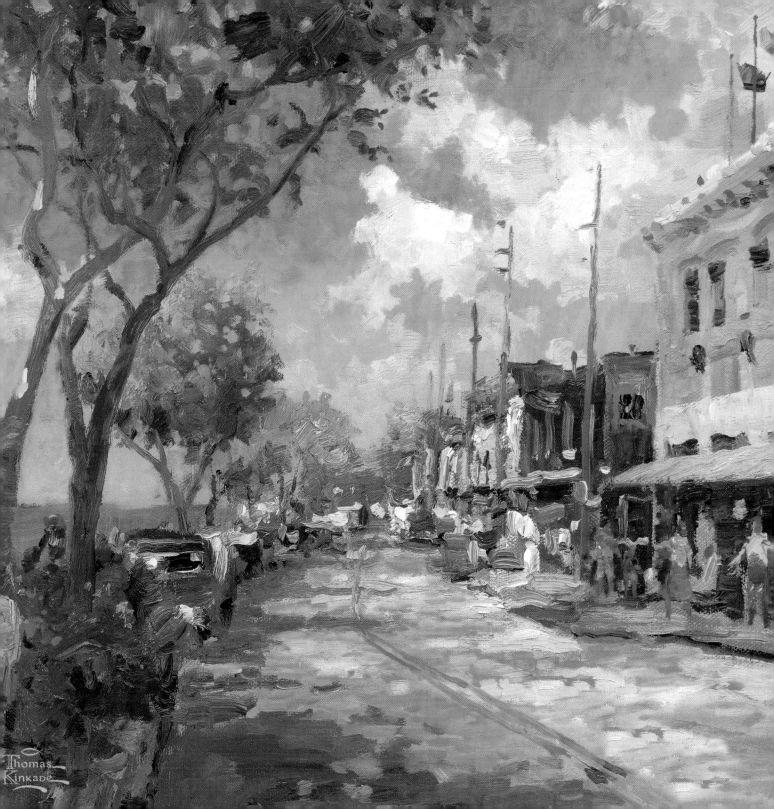

Charles Warren Stoddard has gone to the Sandwich Islands permanently. Lucky devil. It is the only supremely delightful place on earth. It does seem that the more advantages a body doesn't earn here, the more of them God throws at his head. This fellow's postal card has set the vision of those gracious islands before my mind again, with not a leaf withered, nor a rainbow vanished, nor a sun-flash missing from the waves, and now it will be months, I reckon, before I can drive it away again. It is beautiful company, but it makes one restless and dissatisfied.

MARK TWAIN
In a letter to W. D. Howells, October 26, 1881

Perhaps the most famous of Hawaiian songs is "Aloha 'Oe," written by Queen Liliuokalani, the last monarch of the Islands in 1878. For many years this beautiful song's haunting strains were heard by arriving visitors as a lei of ornamental flowers was placed welcomingly around their necks. The song was also sung to those departing the Islands with the hope that they would one day return to this tropical paradise.

The words of "Aloha 'Oe" are, then, a fitting way to end our trip, from sea to shining sea. I hope you've enjoyed accompanying me to some of my favorite places in this great land of America. I trust that my plein air art may even have prompted you to consider visiting some of these sites in person.

God bless, and aloha 'oe, until we meet again.

THOM

Aloha 'Oe

Ha'aheo ka ua i na pali,

Proudly sweeps the rain clouded by the cliffs,

Ke nihi a'e la i ka nahele,

As onward it glides through the trees,

E uhai ana paha i ka liko,

It seems to be following the liko,

Pua ahihi lehua a o uka.

The ahihi lehua of the vale.

Aloha 'oe, aloha 'oe,

Farewell to thee, farewell to thee,

E ke onaona noho i ka lipo,

Thou charming one who dwells among the bowers,

One fond embrace a ho'i a'e au,

One fond embrace before I now depart,

Until we meet again.

Until we meet again.

America the Beautiful

O beautiful for spacious skies,

For amber waves of grain,

For purple mountain majesties

Above the fruited plain!

America! America!

God shed his grace on thee,

And crown they good with brotherhood

From sea to shining sea.

KATHERINE LEE BATES

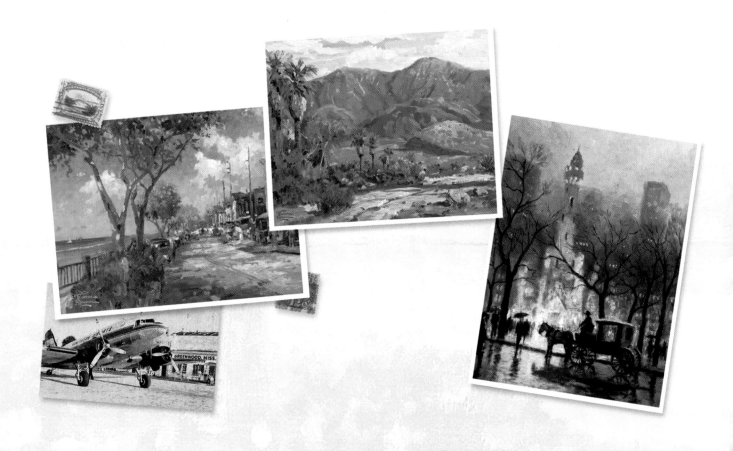

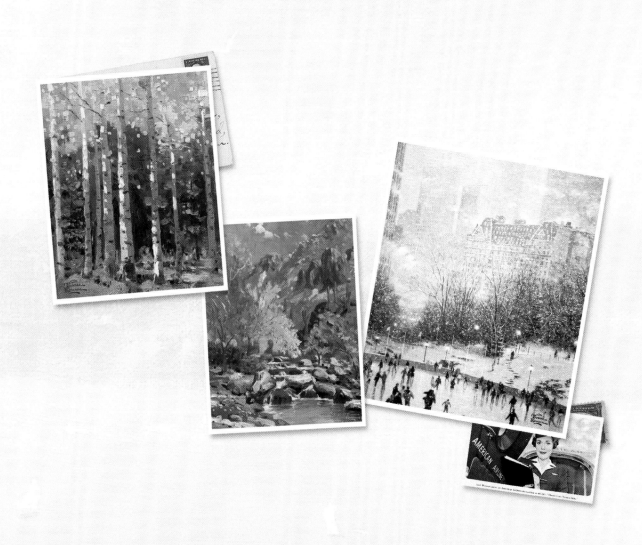

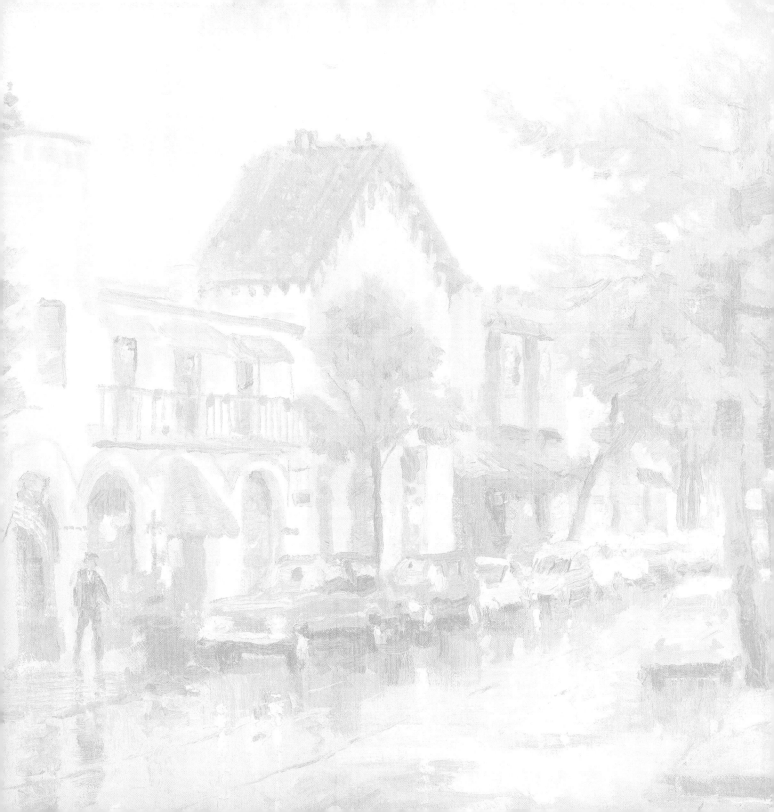